100 KEYS
TO
GREAT
WATER-
COLOR
PAINTING

MIRANDA FELLOWS

CONSULTANT:

NORTH
LIGHT
BOOKS

A QUARTO BOOK

Copyright © 1994
Quarto Inc.

First published in the
U.S.A. by North Light
Books, an imprint of
F & W Publications,
Inc.
1507 Dana Avenue
Cincinnati, Ohio
45207

ISBN 0-89134-565-5

This book was
designed and
produced by
Quarto Inc.
The Old Brewery
6 Blundell Street
London N7 9BH

Manufactured by
Bright Arts (Singapore) Pte Ltd
Printed in Singapore by
Star Standard Industries Pte Ltd

Contents

INTRODUCTION by Hazel Soan

THE SUN IS AT its zenith, the dazzling noon-day light creates short, exciting shadows – your watercolor is looking good, but it's drying too fast ...

Painting the delightful debris of a picnic lunch, the crumbs of freshly baked French bread scattered over the gingham cloth – you want to erase your pencil lines and lighten the background, but you've left your putty eraser behind in the hotel room ...

If only you had a pocket-size book full of all those useful tips you know other people know but you don't, all your problems would be solved.

100 Keys to Great Watercolor Painting is a compilation of exactly those small gems of advice that make watercolor painting more manageable, more enjoyable and, dare I say it, easier!

Watercolor is an exciting and challenging medium. Beginners, in particular, can feel bewildered by a host of supposed rules. Even those artists like myself who paint in watercolor regularly and have acquired the confidence of practice find themselves locked into habits that would benefit from being broken. One word of advice from another artist can release a whole torrent of ideas. One seemingly simple tip can unleash a whole wave of creativity.

Sometimes you wonder just how an artist achieved a certain technique; you've searched through all the books on watercolor, but still it eludes you. Maybe it was something so simple and basic that no one bothered to mention it.

When I was asked to read the manuscript of *100 Keys to Great Watercolor Painting*, I was expecting to find that I already knew or had used most of the keys at one time

or another. I was surprised and delighted to find a lot of ideas I'd never thought of, some of them so simple they seemed like common sense when I saw them in black and white. That is the real beauty of this book: the majority of the ideas require no extra purchases, no extra space, and no heavy reading.

The book is designed to make access to the key you need as straightforward as possible. The sections are clearly titled, starting with a general section and then moving on to more specific areas. The 100 keys are divided into sections highlighting the most common problem areas for watercolor artists. They cover the materials used and the painting in progress, running through washes, special effects, highlighting and masking, with small sections on altering and erasing, body color and colored grounds, and brief hints on traveling light! This is not intended as a book on watercolor techniques. The keys are short and to the point, and are also brightly illustrated in all but a few cases.

You can have fun just trying out some of the keys. A lot of new ideas result from playing with watercolor rather than trying to make finished paintings. This is true both for the beginner and for the seasoned artist. I have enjoyed experimenting with ideas in the Special Effects section, making quick tiny watercolors just to try out the effect. Some of these "dispensable" paintings have more vibrancy than a finished painting because they were done in such a relaxed manner.

100 Keys to Great Watercolor Painting is a book for "dipping into" as the need arises: perhaps before, definitely during, and undoubtedly after! It is the kind of reference book you need to keep with you and which can never outlive its usefulness. Its size makes it a practical addition to the art bag, paintbox, or smock pocket.

I highly recommend this small volume. Don't leave it on the shelf; it is one of those books that is happier well-worn, paint-spattered, and covered with thumb prints!

MANAGING YOUR WATERCOLORS

One of the disadvantages of watercolor is that you don't always know what it is going to do. One color has a way of running into another just when you don't want it to, and refusing to do so when you do. The tips in this chapter provide some useful hints on how to make the paint "behave itself," as well as giving practical basic advice on colors.

1 **PRESERVING PAINT** To prevent your watercolor pans from drying or cracking up, mix them with gum arabic. If you don't have any gum arabic, put a blob of honey or glycerin onto the dried-out pan instead. Allow the glycerin or honey to soak into the paint before you start using it. This will make the paint more soluble, while retaining some of the moisture in its composition.

2 **FASTER DRYING** If you are working in damp weather and find that your watercolor is not drying quickly enough, use a hairdryer to accelerate the process. However, be careful when working across very wet pools of color, as the dryer can easily blow and smudge your work.

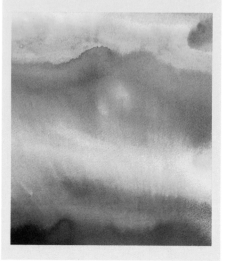

3 **ALCOHOL MEDIUM** If you do not have a hairdryer for speeding up slow-drying washes, try adding alcohol to your paint as an alternative. In the days before the invention of hairdryers, gin added to the paint water was a popular choice for accelerating the drying process because it evaporates more quickly than water.

4 **SLOWER DRYING** If you want to work with watercolor over a long period and so need to prevent it from drying out, mix it with ox-gall or a similar flow-medium which will retard the drying process. There are three ways of using flow-medium: you can prime your paper with it and then paint over it when dry; you can mix the medium with your water and then use the water to mix your paint; or you can mix the flow-medium directly into the paint on your palette. An added advantage is that flow-medium increases the vibrancy of your watercolors.

5 **SOAKING THE PAPER** If you work slowly and watercolor seems to dry too fast for your requirements, soak the paper in water for at least 15–20 minutes before you stretch it and start painting. This will mean that it stays wet for longer.

6 **THE BEST PAINT** Although it may seem expensive to buy artist-quality watercolors, they are worth the extra cost. Because there is a higher proportion of pigment to binder, the colors are purer and more intense. The paints are also available in a wider choice of colors, and many are more lightfast than their cheaper equivalents.

7 **WATER** Always have three pots of water ready when you paint: one of clean water for loading brushes and wetting the paper; one of constantly replaced clean water for mixing with the paint to produce clean, clear colors; and one for rinsing brushes while you work.

8 **WORKING BIG** When you work on a large scale, try mixing watercolors in containers, rather than in your paintbox. This means you can paint quickly and smoothly without having to stop to mix more colors, and you will be able to store the fluid for following sessions, retaining the exact color mix required.

9 **DECEPTIVE COLOR** Do your watercolors always look washed out when you have finished? This may be because you used too little pigment with too much water. Very wet color looks deceptively strong and will dry lighter.

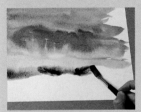

The colors in this variegated wash are still wet and appear bright and vibrant.

Once dry, they have paled considerably.

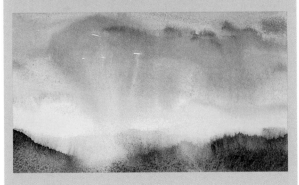

10 **TESTING COLOR** Always keep a small piece of watercolor paper beside you to test the mixtures and strengths of colors before you use them on your painting. If you note the color mix beside each test mark, you will always be able to remix any color for further applications.

Viridian + Cerulean

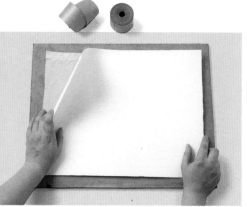

11 **KEEPING PAPER DAMP** If you want your paper to retain dampness throughout the painting process, place a cloth soaked in water underneath it and leave it there while you paint. To stop the paper from cockling, press it tightly over the cloth and attach the edges to the board with gummed-paper tape.

13 **WATER QUANTITIES** If you have trouble measuring the right amount of water to mix with your watercolor, try adding the water to the paint with a pipette tube. This way, you won't overwater or spill water, and the device is also useful for sucking paint from a palette and storing it in a bottle for later use.

12 **TESTING FOR DRYNESS** Touching the surface of your watercolor with your fingers to test how dry it is can easily leave grease marks on the paper, to which paint will not adhere. To test for dryness, try using the back of your hand instead. It is a more sensitive receptor than the fingers and will quickly detect any remaining dampness.

14 **BETTER BLENDING** If you add a little gum arabic to your water when mixing paint, it becomes less runny and easier to blend. This is particularly useful if you are building up a painting in a series of small brushstrokes, as they will remain separate rather than flowing together.

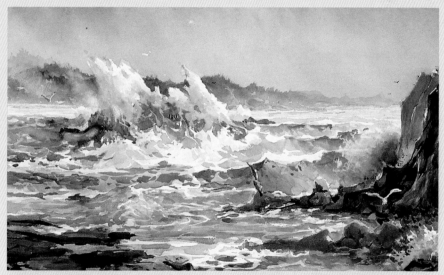

In La Vere Hutchings' painting, "Monterey Bay," the sparkling effect of the breaking waves is created by reserving white paper.

15 **REFLECTED LIGHT** If your watercolors look dull, you may not be taking full advantage of the whiteness of your paper. The brightness of watercolor paint comes from the reflection of light from the white paper back through the paint. Think of the paper as an extra color on your palette, and let it do some of the work for you.

16 **DRIED-UP PAINT** Rather than throwing dried-out tubes of paint away, split them open and use the remains as pan watercolor. But be careful: some tube colors become less insoluble when dry and will create a flaky solution, so test them first.

17 **BLENDING TONES** To prevent harsh edges from forming between light and dark tones, dampen the paper in both the light and dark areas to allow the paint to spread. Then lay the light tones down first, and allow the paint to flow into areas which will then be colored with darker tones.

Elizabeth Apgar Smith, "Lilies" (detail).

18 **BACKRUNS** If you place wet paint next to an area which appears to be dry but isn't, the fresh watercolor will suddenly bloom into the semi-dry area, usually creating unplanned effects. This is called a backrun. To avoid them, always check that areas you want to remain untouched are completely dry before adding fresh paint next to them. However, backruns can create interesting effects that enhance your work, and some artists exploit them deliberately.

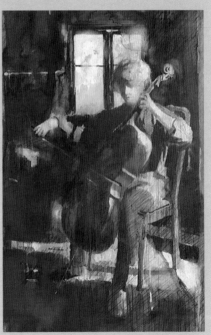

In John Lidzey's lovely painting, backruns on the wall and window create attractive effects.

WATERCOLOR PAPERS

If you visit a specialist supplier, you will find a bewildering variety of handmade watercolor papers, but most artists use machine-made papers available from all art stores. This chapter will help you make an initial choice, and you can experiment with more exotic papers later if you wish. There are also tips on stretching paper and dealing with problems such as creasing.

19

AN ALL-ROUND PAPER Most watercolor paper is made by machine, though you can also buy handmade papers, which have a high rag content. They are expensive and not usually available in ordinary art stores. Machine-made papers come in different surfaces, of which there are three main categories: smooth (otherwise known as hot-pressed or HP for short); medium (sometimes called cold-pressed or CP, but most commonly known as Not); and Rough (also cold-pressed, but with a much more pronounced texture). Although some artists choose smooth or rough paper for special effects, the all-round favorite is Not, which has enough texture to hold the paint but not enough to interfere with color and detail.

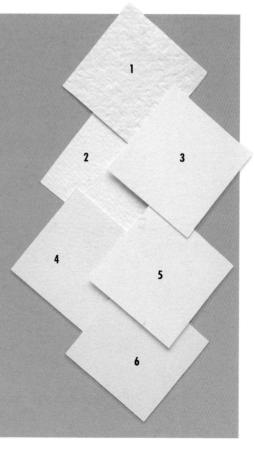

1 Handmade paper.
2 Extra rough mold-made artist's board.
3 Not paper. 4 Rough machine-made paper.
5 Smooth machine-made paper. 6 Not paper.

20 **HEAVY PAPER** If you want to experiment with textures and effects on watercolor paper, use a good, heavy paper or watercolor board which will take real punishment. A heavyweight paper or board will not need stretching and should soak up a lot of water without disintegrating. This helps to retain the transparent quality of the watercolor paint. You can also use a sponge to remove or add color.

21 **STRETCHING PAPER** Thinner watercolor papers need to be stretched so that they don't buckle when paint is applied. When stretching paper, sponging the painting side can sometimes stir up the surface. To avoid this, smooth paper towels over a board. With the top side of the paper placed face down on the paper towel, sponge the back of the paper. The paper towel will absorb any residual water which has seeped through to the top side. Next, turn the paper over and remove the paper towel. Then tape down the paper with gummed-paper tape. Using this method, the painting surface remains undisturbed, no dust or specks are picked up from the board, and any prior drawing remains intact.

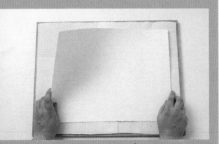

Place the paper over paper towels.

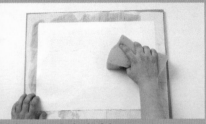

Lightly sponge the back of the paper.

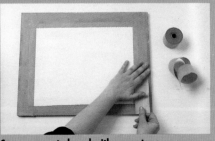

Secure paper to board with paper tape.

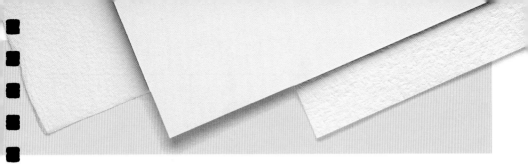

22 **REMOVING CREASES** If you have accidentally creased your paper while stretching or painting, it can often be smoothed out when dry by ironing the back of it with a warm iron. Lay it face down on clean white paper to protect the painting.

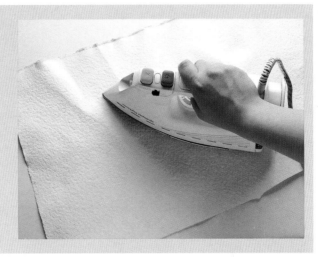

23 **BUCKLED PAPER** If your paper has buckled, it is often possible to stretch it after you have finished the painting, unless there is a heavy buildup of paint. However, be very gentle with the painted surface.

24 **FLATTENING PAPER** If your paper buckles, allow it to dry out completely, place it between two sheets of blotting paper and put weights over the top.

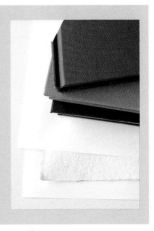

17

BRUSHES AND BRUSHSTROKES

Most people will know that the best brushes for watercolor work are sables, and that they are very expensive. But there are many other brushes you can use, such as household brushes which are ideal for large washes. This chapter will help you to make wise choices, as well as learn to exploit the marks of the brush so that they play a part in your work.

25 **LOOSENING UP** To loosen your painting style and add a sense of spontaneity to your painting, try holding the brush at the top end, so you are forced to make quick dashes of color. This will prevent you from working too lightly.

Holding the brush at the top encourages a looser, freer approach and more expressive strokes.

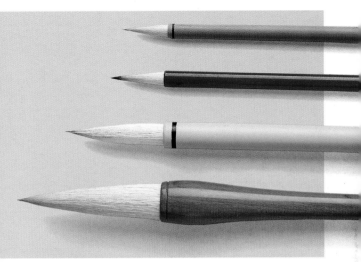

26 CHINESE BRUSHES

If you can only afford a few brushes, Chinese brushes are a wise choice. They can create both very broad and very fine marks, and large, round, Chinese brushes are not as expensive as the equivalent sable ones.

27 TESTING BRUSHES

The better the quality of your brushes, the better your brush marks are going to be, so check the quality of any round or pointed brush by painting a fine line with it. The point of a good brush should give a fine line whatever its size.

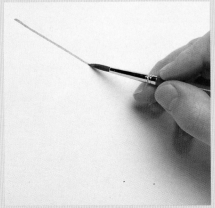

With a pointed brush, the line created is delicate.

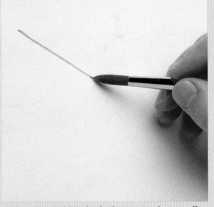

With a rounded brush, the line created is equally clean.

28 **BRUSH QUALITY** A good brush should have a certain resilience. You can test the spring of your brush by wetting it into a point and dragging it lightly over your thumbnail. It should not droop but spring back.

29 **WATER RETENTION** To test whether a brush will hold a suitable amount of water, try moistening it with your mouth. Do not try this with a paint-loaded brush, however, as trace elements from the paint can be retained in the body.

30 **STRAIGHT LINES** Although long, straight lines can be made using a round brush, for variety try a "writer" or a "striper," which were traditionally used for this role. Writers are long-haired sables which taper to a point. They are also called riggers, as they were used to paint the rigging on ships. Stripers are long-haired sables which form a chisel edge. Different-size brushes produce different line thicknesses.

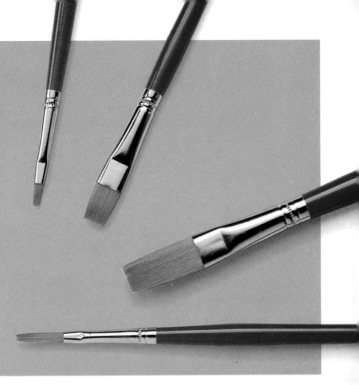

31 BROAD LINES

One-stroke brushes, commonly made from synthetic or ox hair, are good for creating broad lines. Short flats and long flats can also be used. They are all chisel-edged and held in flat ferrules. Short flats are particularly suitable for applying short dabs of color, while long flats hold enough paint for you to make one stroke across your paper.

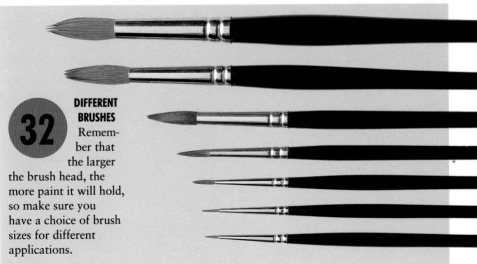

32 DIFFERENT BRUSHES

Remember that the larger the brush head, the more paint it will hold, so make sure you have a choice of brush sizes for different applications.

WASHES

The first skill the watercolorist must master is that of laying a perfect flat wash. This takes a little practice. However, as this chapter demonstrates, there are many ways of guaranteeing success, and you can then move on to more ambitious projects, such as graduated and variegated washes and working wet into wet.

33 **DAMPENING THE PAPER** For a really even flat wash, dampen the paper with a sponge or large brush to help each "band" of color flow into the adjacent one.

34 **SPREADING COLOR** If the paint "furs" downward (spreads in little, feathery lines) when you are painting a wash on wet paper, tilt the board sideways or diagonally to disperse the color in all directions.

35 **ALTERNATIVE WASH BRUSHES** An old, worn-down shaving brush or a household paint brush are both very effective for creating really large washes.

37 **EVEN TONE** If a flat wash is uneven in tone, you may not be charging your brush fully enough. Do not press too hard with your brush, and do not overcharge it with paint or you will create unwanted streaks. Once you have laid down a wash, avoid going over it again, as this will definitely result in streaking.

36 **FLAT WASHES** When painting flat washes (washes that are the same color and tone all over), always mix more paint than you think you will need. The wash will be spoiled if you have to stop and mix more paint.

38 **GRADUATED WASHES** When creating a wash that blends from dark to light in the same color, lay the first band at full strength, then dip your brush first into the water and then into the paint for each successive band. This guarantees that the wash mixture becomes lighter by the same amount.

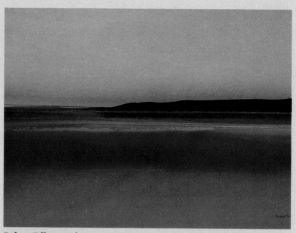

Robert Tilling makes expressive use of washes in "Grauville Bay, Jersey."

39 **UPSIDE-DOWN WASH** If a graduated wash needs to appear more concentrated in color toward the bottom of the paper, turn the board upside down and start from what will be the bottom, working toward the top.

40 **MERGING TONES** When you have completed a graduated wash, work over it gently with a clean, damp, one-stroke brush to merge the change in tones.

VARIEGATED WASHES To create successful variegated washes (ones in which different colors are blended), apply each color side by side and let them bleed into each other.

Yellow applied next to wet blue.

Where the two washes merge, they create a third color, green.

MUDDY COLORS If you often achieve muddy results with variegated washes, you could be working too fast, with the result that the colors bleed into each other too much. To avoid this, apply your first color, then let it start to dry before adding the next. Use only one stroke of the brush to apply each line of wash. Work methodically in this way until you have applied all of the washes. Judging when to add the next color is a matter of practice and experience.

In Alan Oliver's "Poppy Field," the colors are fresh and clear.

25

43 **DROPPED-IN COLOR** If you want to add special effects, like light-colored clouds, try dropping clear water into semi-dry paint. To create denser effects, drop Chinese white or white gouache onto a damp wash. A very liquid, darker color will bleed into the surrounding wash and produce more dramatic effects. Experimental washes such as these might form an attractive background for a still life, suggest clouds, storms or distant trees, or provide an abstract quality.

Water is dropped onto still-damp blue paint.

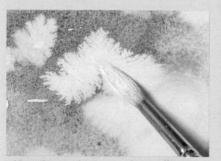

Adding Chinese white creates denser effects.

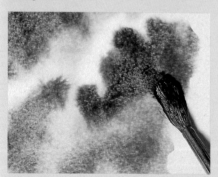

A darker liquid color creates dramatic effects.

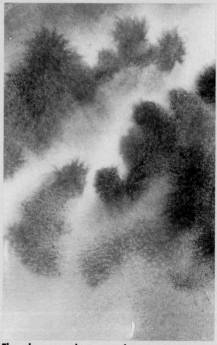

The colors merged to create abstract patterns.

44 **MEETING AN EDGE** If you only want your wash to cover part of the paper – for example, when painting a sky around chimneys – start laying the wash from the edge of the chimneys, rather than having to meet this intricate edge when finishing the wash. Tilt the wash away from the chimney edges to prevent pools of paint from gathering there unless desired.

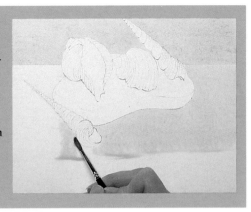

45 **MASKING OUT** If you do not seem able to create clean washes over areas that you have blocked out with masking fluid, try to create the color density and effect you want with only one stroke. If you work over the wash with further strokes, the effect will be less successful.

46 **IMPROVED COVERAGE** If white pinpricks appear on the surface of your watercolor paper when you are painting a wash, mixing a drop of ox gall into the paint will both increase its flow and help its coverage.

47 **PENCIL WASHES** You may have problems creating broad washes if you use watercolor pencils. One method, on pre-wetted paper, is to scrape dry pigment with a mat knife from the pencil point onto the wet paper. Brush this in to dissolve the scrapings. Alternatively, scrape pigment into a dish of water until the desired density of color is reached and then brush it onto the paper as if it were watercolor paint.

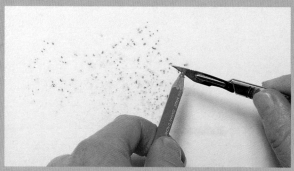
Scrape the pencil pigment onto wet paper with a mat knife.

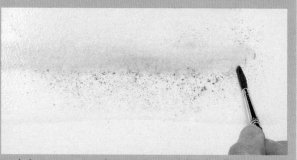
Brush the scrapings into the wet paper until they dissolve.

48 **SOAKING UP DRIPS** If you find that drips collect at the bottom of your paper when you are painting a wash, place soft facial tissues across the area where the wash is intended to finish, and it will soak up all the drips.

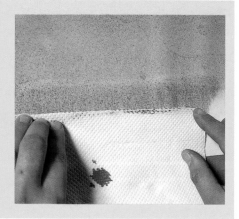

49 **EXCESS WATER** To avoid leaving a thick pool of paint at the bottom of the paper, pick up the paint from the previous stroke as you work your way down the paper, mopping up the edge of the paint as you progress. When you reach the bottom of the paper, carefully pick up the pool of color which has accumulated there with a barely damp brush.

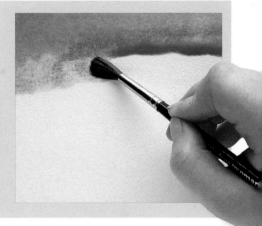

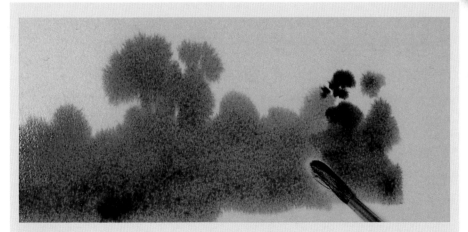

50 **WET-IN-WET** If you always seem to be left with pools of water when you are creating wet-in-wet washes (painting into an area that is still wet), you might be applying the second layer of paint before you have allowed the paper to soak up enough of the first wash. As water soaks into paper, it begins to lose its shine. Once a lot of the water has been soaked up, a brushload of paint will still flow freely, but you will have more control over it. When the paper loses its shine completely, but is not yet dry, you can control the paint you apply even more, while still being able to achieve soft-edged effects for such subjects as bushes or trees against a horizon.

51 **RETOUCHING** If you try to retouch a semi-dry wash, you will be left with blotches. Let it dry completely first, then dampen around the area and touch in gaps with the point of a brush.

52 **REMOVING A WASH** If a wash is developing in patches, stripes, backruns, or with any other unwanted effect, flood the paper with water immediately, lay blotting paper over the area, and lift it all out. Repeat if necessary. If part of the wash has already dried, wait until it is completely dry, then brush clean water over the entire area. The paint should then spread out evenly.

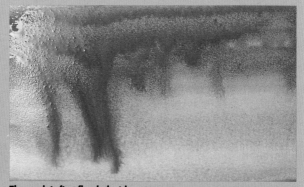

The wash is first flooded with water.

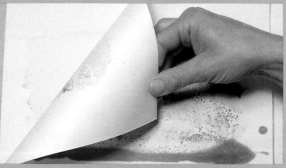

Blotting paper is pressed onto the wet paint and then removed, lifting the color away.

SPECIAL EFFECTS

One of the joys of painting is discovering what the medium can do, and through the decades, watercolor painters have invented and perfected many different methods and "tricks of the trade." Some of them derive from exploiting the "happy accidents" that occur in watercolor work – for example, a wash that has gone wrong and formed blotches and runs can suggest a whole new approach. With practice you will find your own watercolor tricks and techniques, but why not benefit from the experience of others initially, and try out some of the fascinating methods shown in this chapter?

53 **SOFT GLAZE** To create a soft glaze over dry work and to vary the surface colors, use a diffuser to blow out a fine spray. For the best results, make sure that the watercolor is completely dry before you add the spray. You can use a mouth diffuser – sold for applying fixative in pastel work – or experiment using a plant sprayer, which is also useful for redampening watercolor paper while you are working. Do not hold the diffuser too close to the work while spraying, or you will make areas of the paint run into pools.

A quantity of paint is mixed and applied with a plant sprayer.

This creates an uneven "wash," adding surface texture.

54 **PAINT RUNS** If you want to create an unusual wash while the work is still damp, direct a soft spray of water onto the surface. It will dislodge the damp pigment, causing it to run into surrounding areas. If the area sprayed is very wet, most of the color will run. If it is fairly dry, only a little will run, leaving a light coloration in its path. Once you have sprayed the surface, you can direct the water's run by guiding it with a brush or by tipping the painting slightly. Alternatively, allow the paint to run freely. Using this technique, you can blend one color into the background or bring a background color into the foreground. Spraying an area of more than one color will produce a more interesting run than a single color.

55 **INK BLOTS** You can use watercolor inks experimentally to free up your technique and also as a novel way of suggesting the texture of foliage, flowers or pebbles. If you drop ink from a height, it will form a blot. You can produce different effects by changing the height, diluting the ink, tilting the paper, flicking the wet ink to form spatters or blowing on the wet ink so it makes tendrils. Sometimes the random effects formed will suggest a subject that can be developed more representationally; at other times, the effects will simply make a pleasing background.

56 **SOFTENED EDGES** If soft features such as clouds look too strong against a wash, use a cotton swab to blend the edges into the wash while the paint is still wet.

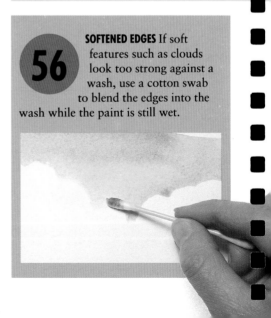

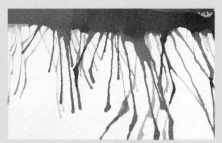

Blowing on wet ink creates tendrils.

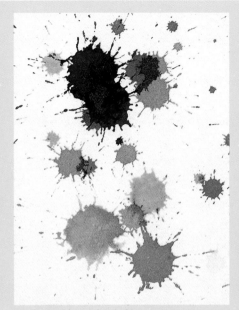

Ink dropped from a height blots and spatters.

Experiment with different random effects.

57 **EXPERIMENTAL TEXTURES** Don't be afraid to experiment with texture. Try applying paint with a variety of household items, including potatoes, cardboard, rags, razor blades, sandpaper, rubber spatulas, and credit cards. Rub or scratch them over the paper.

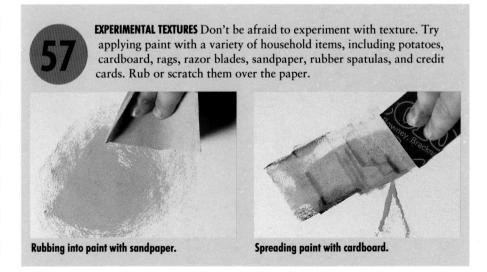

Rubbing into paint with sandpaper.

Spreading paint with cardboard.

58 **PENCIL TRICKS** To create interesting textures with watercolor pencil, take two different-colored pencils and scrape pigment off them. Then wet a large round brush and pick up traces of the pigment scrapings. Paint directly onto the paper or the watercolor to create unusual blends and textures.

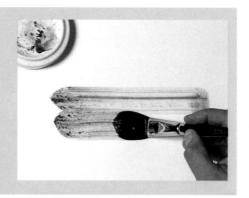

59 **SPATTERING** Rather than following the normal practice of using a toothbrush for spattering, flick a pre-wetted brush across the tip of a pencil. A moist, thin brush will give a fine effect, while a large, very wet brush will give a more generous, random result. This effect can be achieved on wet or dry paper.

Large wet brush with wet paper.

60 **SPECKLED EFFECT** To add interesting texture to your work, try scraping dry pigment from a watercolor pencil over wet work. As the pigment flakes, it will stick to wet areas in the painting. You can then blow any excess away when the paint has dried.

61 **BLOWN TEXTURE** Allow a variegated wash to dry completely, then blow paint down a straw, following the line of the paper upward to create interesting textural effects.

62 **SPONGING** A small, natural sponge dipped in a pool of watercolor and dabbed on the paper will create interesting effects for such features as foliage, rocks, or sand.

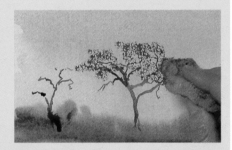

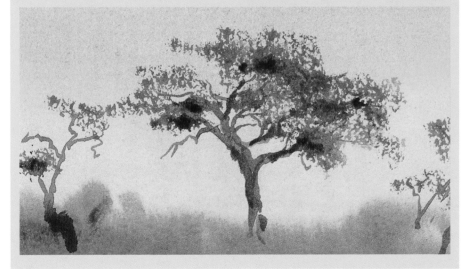

63 GRAINY TEXTURE

To create a texture similar to sand or snowflakes, try sprinkling grains of coarse salt into wet paint and then brushing them off once it is dry.

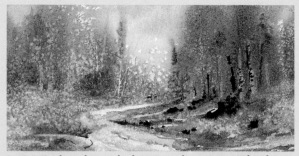

La Vere Hutchings has used salt spatter in her painting "After the Frost," of which a detail is shown here.

64 ROLLED-ON COLOR

To apply a textured wash of color, squeeze some color from a tube onto a piece of glass or plastic, then mix it with a small amount of water and apply it with a roller on unevenly dampened paper. The roller will disperse the color in blotches over the driest areas of the work, creating interesting textures. In the more heavily dampened areas, the paint will spread evenly onto the paper, leaving soft edges.

65 ADDING SHINE

A brushful of gum arabic mixed with the paint makes it slightly shiny and more viscous. It allows the paint to dry on the surface of the paper instead of sinking in. This makes lifting off the paint very easy. Interesting wet-in-wet and textural effects can be achieved with this slightly slower-moving paint, especially if you spatter it with water or another color when dry or half-dry. A drop of gum arabic mixed with strong colors will prevent them from looking dull and flat – any more than a drop will cause the paint to become shiny, and it may crack in time.

66 **MIXED MEDIA** Watercolor washed over wax crayon, pastel, or oil pastel creates exciting textures and has the added advantage of binding the medium underneath.

67 **LIFTING OFF** Blot out un-wanted runs, bleeds, or blocks with highly textured paper towels. This is particularly effective on medium-surfaced (Not) paper. It will not leave a smooth mark, as blotting paper does, but the imprint of the rough surface of the paper.

68 **USING MASKING FLUID** If your painting is dry and a particular color is too strong and needs lightening, try using masking fluid as an alternative to blotting paper or a damp sponge. Apply the fluid over the area to be lightened, allow it to dry, then remove it.

Masking fluid has been used to create a soft, broken highlight.

UNDER THE FAUCET Unusual effects can be achieved by running hot or cold water over your painting at various stages of its development.

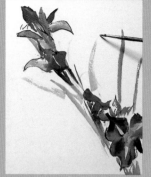

Flowers are painted strongly.

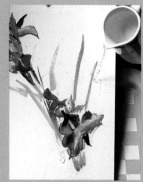

Cold water poured on paper.

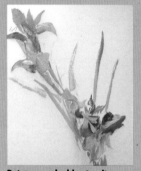

Paint spreads, blurring lines.

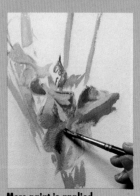

More paint is applied.

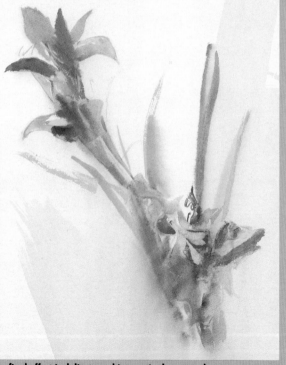

The final effect is delicate and interestingly textured.

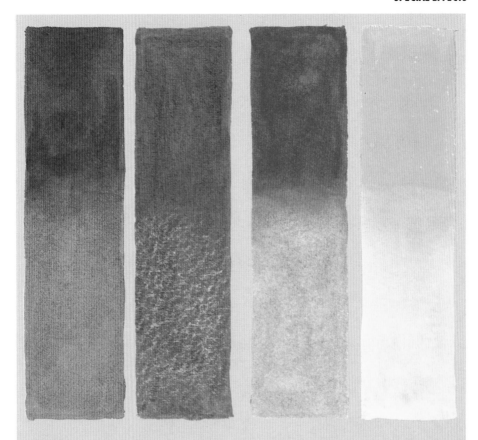

70 **WASHING OFF** If you are using a heavy or prestretched watercolor paper, you can create a texture effect by laying washes, allowing them to dry, and then washing them off. Place your work at a slight angle, then wash the pigment away carefully with a hose. The harder the spray, the more pigment it will remove. Any very thin applications of watercolor will have been almost totally absorbed by the paper's surface, and very little of the color will wash away. Heavily painted areas, however, can be cleanly washed away and may leave an interesting texture. Remember that staining pigments, like alizarin crimson and viridian, leave more color behind. Sedimentary pigments, like cerulean blue and Naples yellow, tend to sit on top of the paper and lift off more cleanly.

HIGHLIGHTS AND MASKING

Because watercolors are transparent, white highlights are achieved by reserving, or painting around the shapes to leave bare paper. Aids such as masking fluid make this once-tricky process much easier. And even if a highlight has become "lost," there are many ways of saving the situation.

71 **LIGHTENED HIGHLIGHTS** Once your painting is completely dry, you can emphasize highlights by rubbing over them gently with a typewriter eraser, sharpened to a point to increase accuracy. This removes some of the top layers of paint, occasionally rubbing down the surface of the paper, and enhances the brightness of shafts of light. The nature of the eraser makes it easier to enhance very specific details.

72 **WIPED HIGHLIGHTS** While a wash is still wet, use a piece of cotton rag to wipe out highlight lines. If the wash has dried, use a dampened tissue to do the same. This technique is particularly effective for light clouds or shafts of sunlight.

73 **SCRATCHED HIGHLIGHTS** Use a mat knife to scratch out color to create detailed highlights. Make sure that the watercolor is completely dry before doing this – not just touch-dry.

74 **ERASER SUBSTITUTE** If you use an eraser too vigorously, it may break up the texture of both the paper and the paint. Crumbs of bread make a gentler eraser to clean up highlights. Knead the bread until it is soft and then use it in the same way as you would a conventional eraser. Do not apply too much pressure or the bread will crumble.

75 **LIFTED HIGH-LIGHTS** To create highlights while a wash is drying, use a dry brush to lift the color out of the area. You will need to repeat this several times because the color will continue to seep into the highlighted areas until the wash is nearly dry.

76 **PASTEL HIGH-LIGHTS** If a lost highlight cannot be regained by any standard method, soft, pale pastel tints used over the area and lightly rubbed in will retrieve the highlight.

77 **GILDED HIGHLIGHTS** An unusual way to pick out highlights in a watercolor painting is to apply gold leaf to areas to be lightened. This is an effect which the painter Samuel Palmer often employed.

First apply size and allow to dry for 20-25 minutes.

Use paper towels to apply gold leaf on the areas you wish to highlight.

After two to four hours, brush excess leaf away. Burnish.

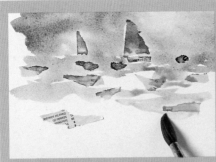

78 **MASKING WITH PAPER** To create random white areas, mask the paper with torn pieces of newspaper before applying your initial washes. For crisp effects, do not remove the newspaper until the wash is dry.

Washes applied over random pieces of paper.

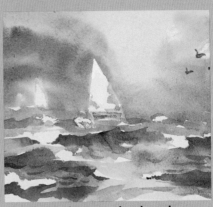

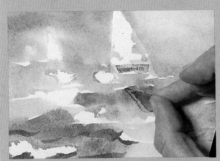

The paper is removed, leaving white shapes.

Final touches of paint complete the work.

79 **MASKING-FLUID HIGH-LIGHTS**

A series of small highlights can be difficult to achieve by reserving white areas of paper. It is far easier and more effective to paint the required shapes with masking fluid.

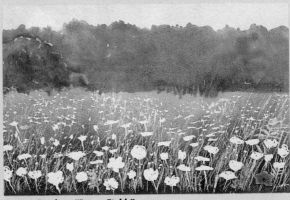

Doreen Bartlett, "Poppy Field."

80 REMOVING MASKING FLUID If
you find it difficult to remove masking fluid cleanly, you may be leaving it on the paper for too long. Once dry, the fluid should be removed as quickly as possible. The prevailing temperature and humidity will affect its drying time. It may help to keep a ball of used fluid, like an eraser, and when you are ready to rub your masking fluid off, roll the ball across it, always starting at the edge. Rolling is also less likely to tear the paper.

81 ALTERNATIVE MASKING FLUID
A good alternative to using masking fluid is white fabric glue, mixed with an equal amount of water and a little nonstaining pigment so that you can see where you have placed it. Nonstaining pigment will also help you to see masking fluid.

82 PROTECTING BRUSHES To
avoid ruining your brush when using it to apply masking fluid, work very quickly and clean your brush out as soon as you have finished. You can protect your brush by coating the bristles with some soap lather before dipping the brush into the masking fluid. The soap will not affect your application of the fluid and will also make it much easier to remove once you have finished.

83 **BRUSH SUBSTITUTES** Instead of applying masking fluid with a brush, try using a pen for masking out fine lines, and cotton swabs for larger areas.

84 **CANDLE WAX** Wax from an ordinary household candle can be used instead of masking fluid to "block" the paint. It is, however, more difficult to remove than masking fluid and is thus usually left on the paper to provide an interesting texture.

Washes are laid over masking fluid applied with a cotton swab.

This has produced very even, regular white shapes.

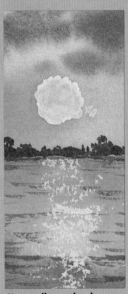

Washes applied over masking fluid applied with a pen.

This produces much finer lines than can be made with a brush.

Hot candle wax has been dripped onto the paper before the paint is applied.

ALTERING AND ERASING

Watercolor painting can be a nerve-racking business, as things often go wrong. But you seldom need to throw the paper away and start again if a wash dries blotchy or if you find you have slopped paint over an edge that was meant to be white. There are many ways of making corrections, and if you are dissatisfied with a finished picture, why not draw on top of the paint with colored pencil or pastel?

85 **BRUSHING OUT** If you think that the edge of a brush-stroke is too hard or soft, and you want to achieve smooth edges, "tickle" them out with the tip of a damp brush.

86 **REMOVING PAINT** Trying to move watercolor once it has dried can be difficult, but it is possible. Once your watercolor has dried, it can still be re-wet, moved around, or partially removed from the paper. A sponge may work better than a brush for this purpose. Bear in mind, however, that most colors can never be completely removed because the pigment in the paint will have stained fibers in the paper. Let the paper dry thoroughly before repainting.

87 **DISGUISING STAINS** After washing out a wrong tone or color, you may have been left with a slight stain. You can paint a thin film of white or suitably tinted acrylic over this, smoothing the edges with a cotton swab. When the acrylic has dried, transparent watercolor can be washed over it.

White acrylic masks mistake. Cotton swab blends white. Watercolor is re-applied.

88 **ACRYLIC SEALER** If your water-color paper is too absorbent, or has become roughened by too much rubbing, a thin wash of white or tinted acrylic will seal the surface. When using acrylic for under-painting, or corrections, it should be used thinly; otherwise, superimposed layers of watercolor may not adhere.

89 **CRAYON REMEDY** Colored pencil or pastel on top of an abandoned or aborted watercolor can pull it all together and create attractive effects at the same time.

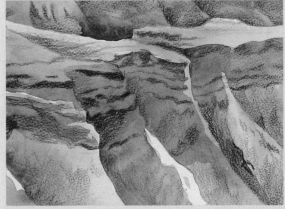

In Hazel Soan's "Fish River Canyon," colored pencil gives texture.

OPACITY

Watercolor is usually thought of as a transparent medium, but it need not be. Some of the great watercolor painters of the past mixed their colors with opaque white paint, and many contemporary artists follow the same practice. If you want to give the paint more body, there are substances you can add to it, such as soap or starchy water – and you won't even need to visit the art store for these.

90 **TINTED GROUNDS** Try tinting watercolor paper with diluted coffee. This was a common practice among early watercolorists and is still a very good way of producing a pale, warm ground. In China, artists use tea leaves to produce similar grounds. You could even tint paper with a used teabag.

91 **ORDER OF WORKING** You do not have to follow the convention of painting from light to dark with watercolor – Turner certainly did not always adhere to this practice. Working on blue-tinted paper, he would first apply "body color" (opaque watercolor), building from dark to light as in oil painting, the reverse of the traditional watercolor process.

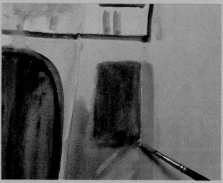

Diluted white paint modifies the darker colors.

92 **OPAQUE MEDIUM** To make your brushstrokes more opaque, follow Turner's example and mix your paint with rice water. You can also try soap, which thickens the paint nicely and leaves small bubbles if applied with a stiff brush.

93 **OPAQUE PAINT** Mixing gouache with Chinese white or white gouache will produce more opaque pale colors. You could also try undiluted watercolor, for example, yellow ocher, or cadmium yellow, on colored Ingres or Canson papers.

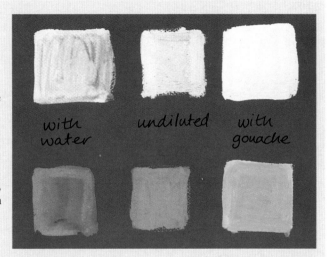

with water *undiluted* *with gouache*

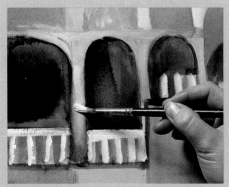

Thicker white paint is now used.

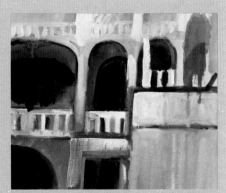

White mixes with colors to create a milky effect.

TRAVELING LIGHT

It's always a problem going to paint in an unfamiliar place because you may encounter quite unexpected different colors. But resist the temptation to buy a whole new set of paints – take as few as possible and welcome the opportunity to practice your color-mixing skills. Some of the greatest watercolors of all time were painted with no more than five or six colors.

94

ADVANCE PREPARATION If you like to work on tinted paper, prepare it in advance, so that when you arrive at your chosen location, you will be ready to start painting. You could even prepare several sheets, mixing up a large quantity of the desired color.

95

RESTRICTED PALETTE If you use tube paints and are uncertain which you will need, take only two versions of each primary color – red, yellow, and blue. This will give you valuable practice in color mixing and will also help to unify your paintings. Experiment at home before you go.

96 **RANGE OF TONES** When painting outdoors, you may not be able to take a wide palette. If you experiment, you will find that with one color you can create infinite tonal variations – for instance, raw umber can appear as everything from a dark brown to a brick brown to a yellow ocher to a cream, simply by the addition of more water.

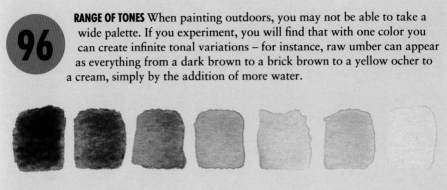

97 **COLOR PATCHES** Choose the colors you will need from a set of watercolor pencils, and rub a 2-inch square of dry pigment from each on to the last page of your sketchbook. Take this, a brush, and some water and, when you are ready to paint, just wet the brush and touch it to the squares of color. You can then blend them and paint on the front pages.

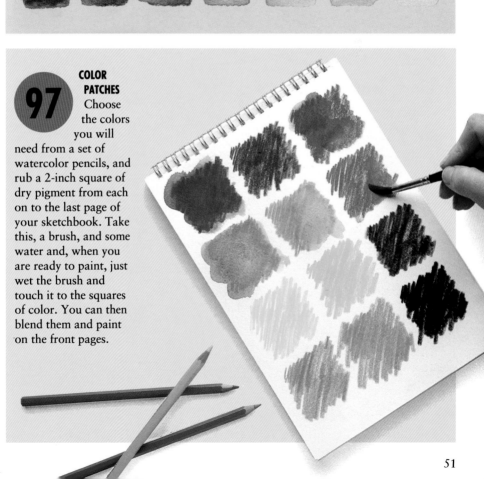

51

98 **WATER SUBSTITUTE** If you run out of water or need to mix color on a palette without much water, a touch of saliva makes an adequate alternative to water.

99 **FINGERNAIL TRICK** When painting on location without your usual "tool kit," use your fingernails if you need to scratch out dry paint for highlights.

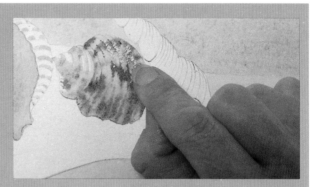

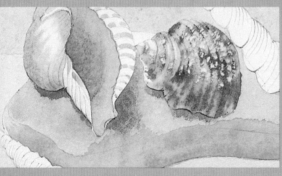

100 **ALTERNATIVE ERASER** If you find you have left your eraser behind, dry French bread left over from your picnic can make an excellent alternative.

LANDSCAPE

When painting landscape, don't make the common mistake of becoming bogged down in detail – think about the painting as a personal interpretation of nature, not as a copy of it.

KEY ELEMENTS It is all too easy to become bogged down in the detail of a landscape rather than see the work as a whole, so that your picture becomes too busy and your final image does not hold together. To create a convincing landscape, concentrate on a few interesting features and use creative licence. To practice this, half-close your eyes to blur the image in front of you and reduce it in your mind's eye to basic areas of tone and form. By freeing yourself of detail, you will find it easier to concentrate on those elements which will make your landscape more successful.

UNIFIED COLOR Paint the sky first and then allow the tonal values across the land to complement the air mass above. To unite the colors in your landscape, repeat sky colors in the landscape below, using blues among the greens, for example. To create a sense of depth, use cooler colors towards the mid-distance and warmer ones in the foreground.

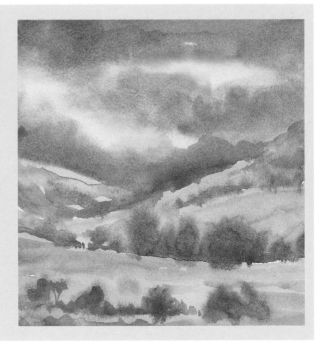

CLOUDS To gauge the true color of white clouds, hold a piece of white paper against the sky and note what tonal variations there are. You may be surprised to realize that few are really white. When the light of the sun is shining directly through a cloud from behind, the outline of the cloud will be clearly defined. If there is no direct sunlight through a cloud formation, the outline will be much more hazy.

CONVINCING REFLECTIONS To test the effectiveness of your reflections, turn your painting upside down and see how convincing the image seems the "right way" up.

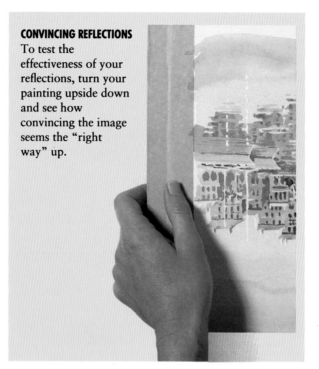

UNDERWATER SUBJECTS When painting subjects submerged under water try to make the surface waterline as clear as possible to make sure that the water retains a sense of depth. To create a fine edge, sharpen a suitably colored watercolor pencil to a point and lightly mark the line with it.

Subject is painted.

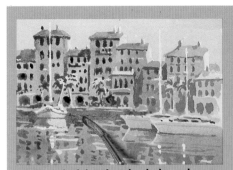

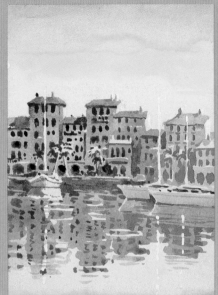

A light wash of sky color is brushed over the reflections.

REFLECTED COLOR The colors of reflections in water should both mirror the colors of the reflected object while incorporating the main color affecting the surface of the water – usually that of the sky. To achieve this balance, try painting a light wash over the reflection using the same color you have used for the sky.

The colors of the reflections are slightly richer than those of the buildings.

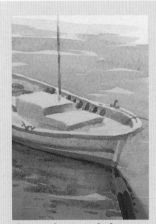

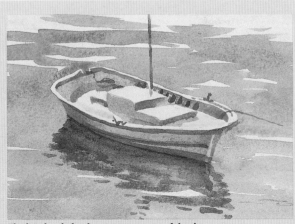

The waterline is marked in.

The line has helped to create a sense of depth.

TREES AND FOLIAGE

The main cause of failure when painting trees is poor observation; look for the real colors of foliage, trunks, and branches instead of painting everything in shades of green and brown. Texture is important, too.

TRUE COLOR If your trees look unconvincing, you may have allowed preconceived ideas about their true color to stand in the way of a realistic depiction. Tree trunks are not usually brown – they are often, in fact, a mixture of grays and greens, and are similar in tone to their branches and leaves.

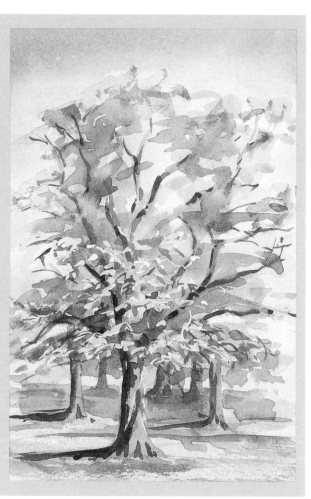

When painting trees, try to integrate the colors of the bark with those of the leaves.

TONES AND ANGLES Do your trees appear flat? If so, make sure the branches protrude at different angles and directions to one another. Include tonal variation through the trunk, branches, and leaves by diluting your color as you work toward the branches and twigs. As the tree branches out, the colors will become paler.

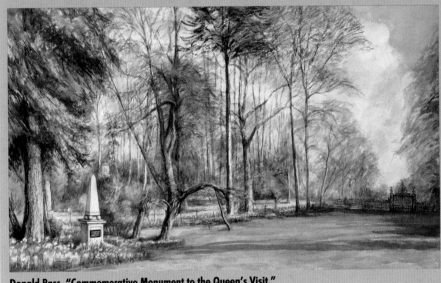

Donald Pass, "Commemorative Monument to the Queen's Visit."

TREE HIGHLIGHTS
Highlights give form and substance to a tree and enhance the textured nature of the bark.

Alan Oliver, "Woodland Clearing."

FOLIAGE The texture of foliage can be hard to recreate in watercolor. A good way to achieve convincing texture is by using wax crayon or oil pastel over flat, dry watercolor.

A household paintbrush is ideal for large blocks of color.

Wax crayon or oil pastel can be added once color is dry.

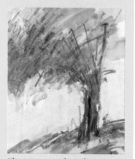

The mixture of media creates interesting textured effects.

DRY BRUSH TECHNIQUE To create textured foliage, dip a brush into the paint, then fan out the bristles between your thumb and index finger, pressing the bristles onto the paper while you paint.

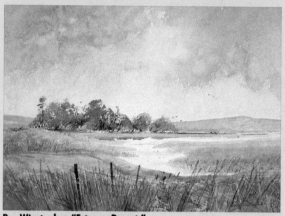

Roy Winstanley, "Estuary, Dorset."

FRESH FLOWERS To convey the organic nature of flowers, paint the overall shapes in lightly, then try dropping in the centers of the flowers wet-in-wet, re-wetting any flowers that have dried with clean water. Allow the paper to dry and then fill in the fine details, either with a brush or watercolor pencil. In this way, your flowers will appear as a vivid combination of spontaneity and intricate design.

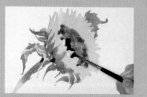

Overall shapes blocked in lightly.

Centers painted wet into wet; watercolor pencil details.

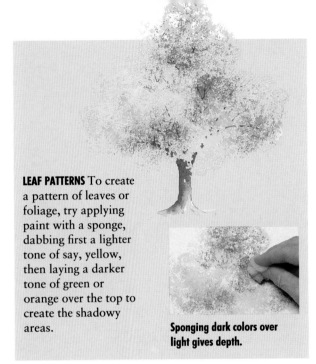

LEAF PATTERNS To create a pattern of leaves or foliage, try applying paint with a sponge, dabbing first a lighter tone of say, yellow, then laying a darker tone of green or orange over the top to create the shadowy areas.

Sponging dark colors over light gives depth.

LEAF VEINS Once you have applied the initial wash of color to the petals and leaves of flowers, mask out the veins while you build up tonal variations. When you have finished, remove the masking fluid; the delicate veining will give the leaves and petals greater authenticity.

Masking fluid is applied over dry wash.

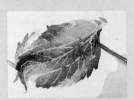

The tones and colors are built up with further washes, and the fluid is removed.

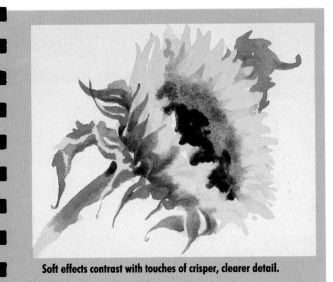

Soft effects contrast with touches of crisper, clearer detail.

BUILDINGS

Watercolor is well suited to painting buildings, as the combination of broad washes and fine, delicate brushwork can describe architectural features with accuracy and sensitivity.

BRICKWORK When painting a brick wall, remember that from a distance not every brick will be clearly defined – rather the viewer will see the overall fabric of the wall, so describing a few bricks here and there will suffice. Begin by laying in a pale wash of raw sienna to provide the background tone. When dry, use a No. 6 chisel brush to paint the bricks and leave spaces between them to indicate mortar. Bricks are not uniform in color, so mix three or four tones before you begin and alternate between them. When the first washes are dry, paint a weak solution of Payne's gray over the top of the brickwork to unify it. Finally, spatter a mixture of Payne's gray and raw umber over the surface to create more pronounced textural effects.

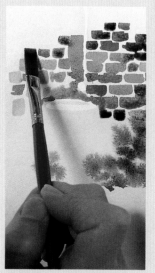

The bricks are painted with a chisel brush, leaving white spaces for the mortar.

SHADING STEPS To paint steps, apply a thin line of paint under the ridges of the steps, and, using a wet brush, pull the paint downward to form the shadow, blotting out rogue runs which you do not want shaded. Alternatively, try wetting under the ridge of the step with plain water first, and then, while it is still wet, draw a line of color under the ridge, allowing it to run into the clean water. Make sure that the band of clear water covers the whole of the vertical plane of the step, but is not so wet that the color runs right down it.

WARM TONES Burnt sienna, with its rich, luminous red tone, makes a good color for adding warmth to natural brickwork.

STRAIGHT STROKES To avoid crooked window frames, use the brushruling technique: hold a ruler at the correct angle to the paper and then carefully glide the brush along it with the ferrule held tightly against the edge of the ruler.

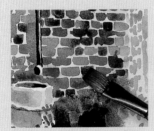

Three or four tones are used to enhance the texture.

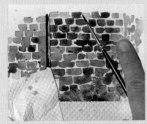

A light spatter of Payne's gray builds up the texture.

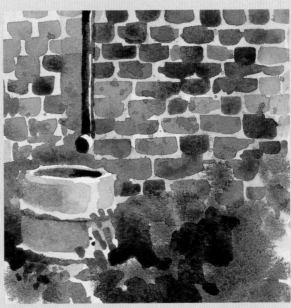

The loose series of brushmarks creates a convincing impression.

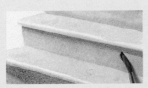

A thin line of paint is applied under the ridges of the steps.

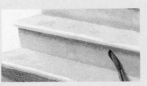

A wet brush is used to soften the edge.

Alternatively, draw a line of color under ridge.

PAINTING PEOPLE

Although portrait painting is best avoided until you are sure of your skills, painting people in a landscape is no harder than painting trees or rocks, and will often give the painting that extra touch it needs.

SKIN TONES If you find it difficult to achieve lively skin tones, try using smooth (hot-pressed) paper instead of standard cold-pressed. Because it has a much harder, flatter surface, it will not soak up watercolor so quickly, making it easier to move the colors around and create soft effects. If you decide to experiment with this surface, you will have to control more backruns and pools of paint. Although the paper is more unpredictable, you will be able to achieve spontaneous and sparkling results.

PEOPLE IN A LANDSCAPE It is best to paint them in with two simple strokes, one lighter to indicate flesh tones and the other over the top when dry to indicate hair or headcovering and garments. The overall shape of the stroke is important: it must be simple and direct.

Light brushstrokes over dried washes suggest the figures.

Darker colors are now added for hair and clothing.

The figures are well integrated into their surroundings.

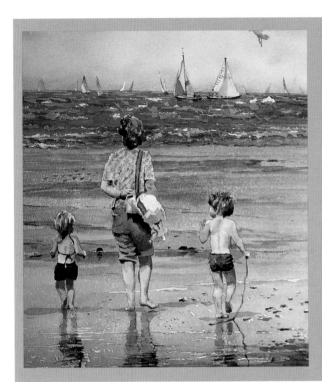

LAYERED TONES Build up skin tones gradually, with very thin, light washes of paint, allowing the painting to dry in between applications to achieve subtle tonal variations. The less you drag the paint around, the more lively the portrait will be.

La Vere Hutchings' "A Day at the Beach" is a perfect example of layered tones (detail).

FLESH HIGHLIGHTS When painting pale skin, allow untouched white paper to depict the lightest flesh tones.

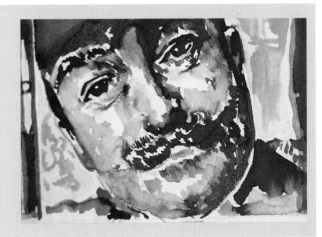

In Paul Bartlett's "Face Looking Through," the colors have been worked rapidly wet into wet.

ACKNOWLEDGMENTS

The author would like to acknowledge the invaluable hints and tips given by the following artists and experts while researching this book: Rosalind Cuthbert, Jean Canter, Moira Clinch, Charles Glover, Hazel Harrison, Emma Pearce (Technical Adviser, Winsor & Newton), Hazel Soan.

Quarto would like to thank Sally Launder, Debra Manifold, Hazel Soan and Mark Topham for demonstrating the techniques.

Quarto would also like to thank Daler-Rowney and Langford & Hill for supplying paints and equipment.

Art editor Clare Baggaley
Designer Clive Hayball
Photographers Paul Forrester, Chas Wilder, Laura Wickenden
Picture researcher Laura Bangert
Senior editor Sally MacEachern
Editors Diana Craig, Hazel Harrison
Editorial director Sophie Collins
Art director Moira Clinch

Typeset by Poole Typesetting (Wessex) Ltd, Bournemouth
Manufactured by Bright Arts (Singapore) Pte. Ltd
Printed in Singapore by Star Standard Industries Pte. Ltd